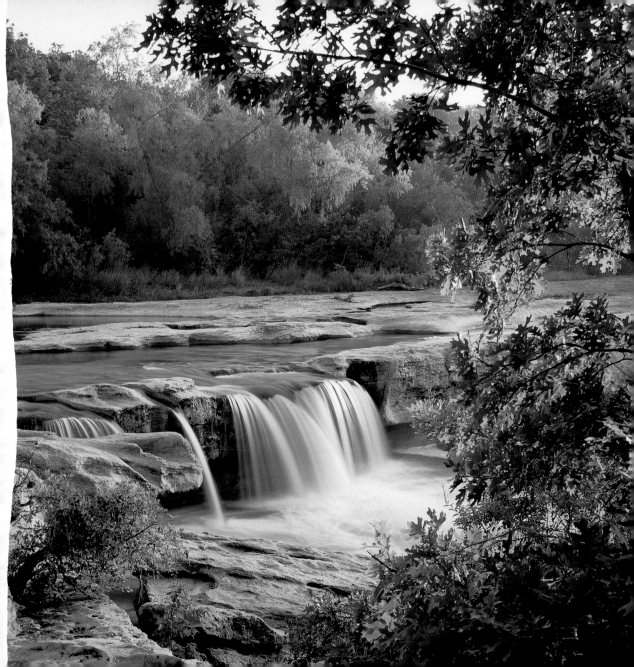

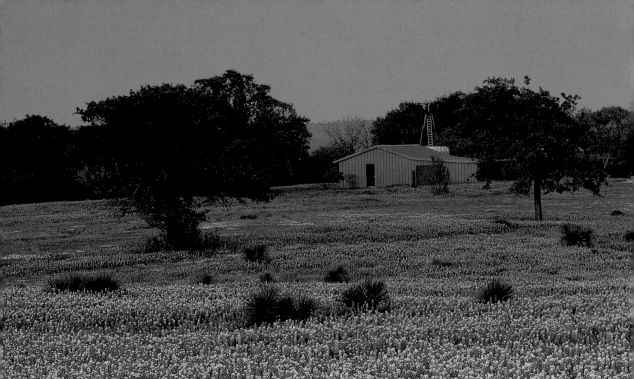

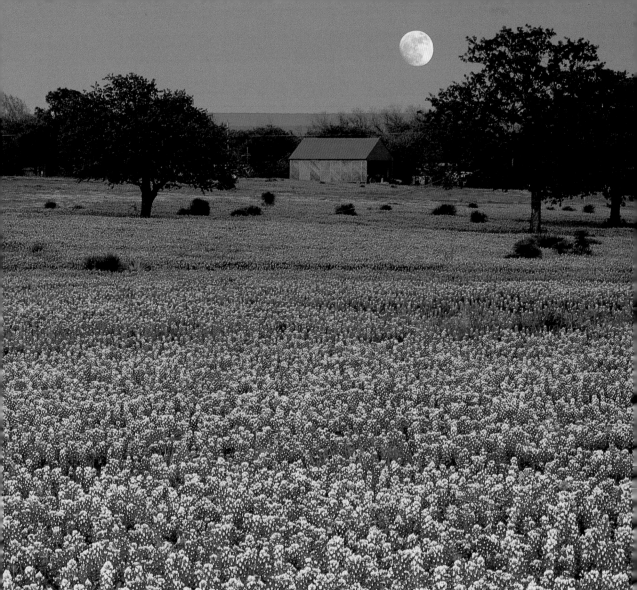

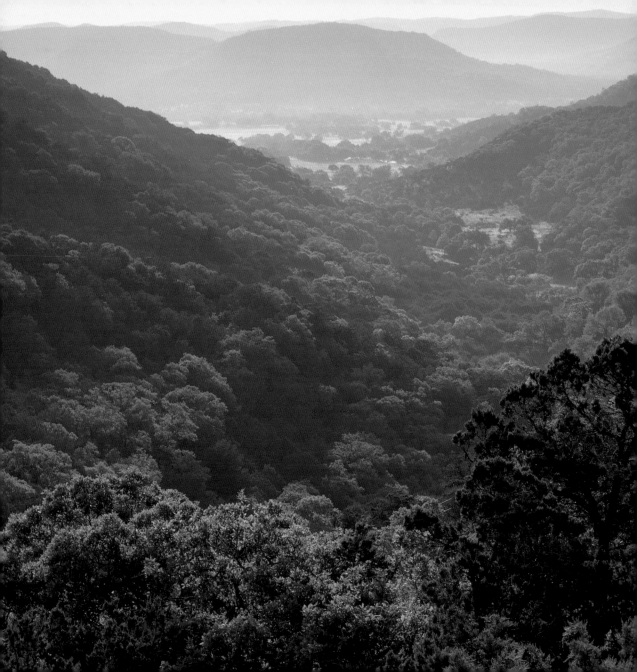

TEXAS
HILL COUNTRY

Photography by Richard Reynolds
With Selected Prose & Poetry

Texas Littlebooks

WESTCLIFFE PUBLISHERS

Englewood, Colorado

First frontispiece: McKinney Falls on Onion Creek, Travis County
Second frontispiece: Full moon and bluebonnets, Llano County
Third frontispiece: Hill Country vista, Bandera County
Opposite: Prairie paintbrush, McCulloch County

International Standard Book Number: 1-56579-145-2
Library of Congress Catalog Number: 95-62425
Copyright Richard Reynolds, 1996. All rights reserved.
Published by Westcliffe Publishers, Inc.
2650 South Zuni Street, Englewood, Colorado 80110
Publisher, John Fielder; Editor, Suzanne Venino; Designer, Amy Duenkel
Printed in Hong Kong by Palace Press

The quote on page 48 is from the book *Adventures with a Texas Naturalist* by
Roy Bedichek © 1947, 1961, renewed 1989. Courtesy of the University of Texas Press.

For more information about other fine books and calendars from Westcliffe Publishers,
please contact your local bookstore or contact us by calling (303) 935-0900,
faxing (303) 935-0903, or writing us for a free color catalogue.

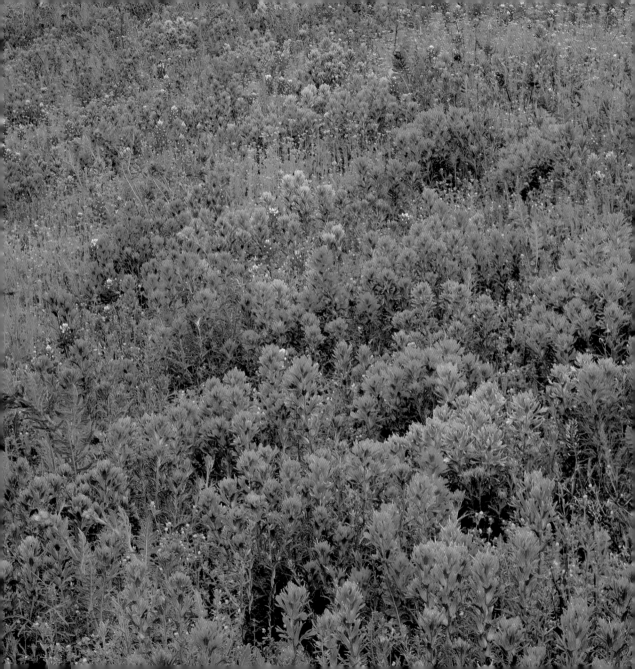

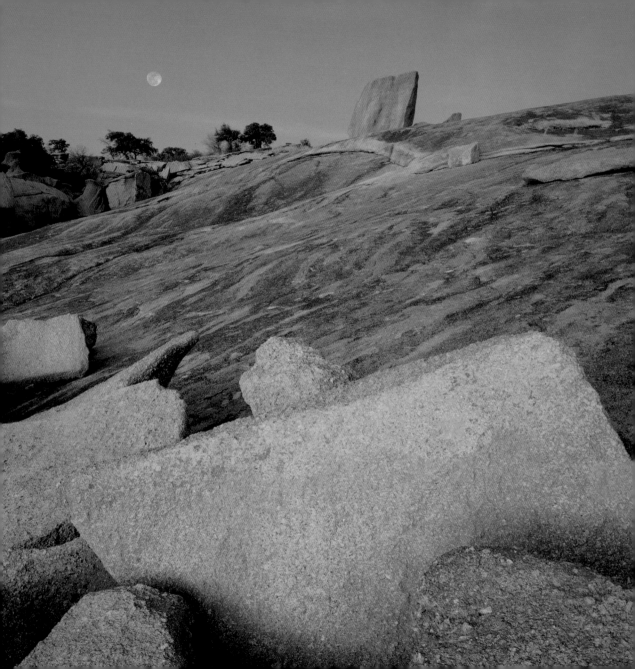

PREFACE

The Texas Hill Country, nestled in the very heart of the state, is as beautiful as it is varied. The geology of the region is particularly diverse, the result of eons of activity that has shaped the landscape seen today.

Bisecting the state in a long line stretching from the Rio Grande to the Red River is a long-dormant fault line known as the Balcones Escarpment. To the east lie the Gulf Coastal Plains, to the west, the Rocky Mountain uplands. The northern end of the Balcones Fault is barely discernible, but in Central Texas the uplifted Edwards Plateau, which begins at the fault line, is highly visible. The cliffs here were appropriately dubbed *balcones* by Spanish explorers.

The Edwards Plateau is a broad band of limestone that to early explorers and settlers was the "mountainous" region of Texas. The eastern third of the plateau lies within the Texas Hill Country. This region is relatively lush and green, receiving about thirty inches of rain a year, as compared to the western two-thirds of the plateau, which only receives ten to fifteen inches.

This portion of the Hill Country is carved in places by deep river canyons. The rivers are fed by springs emanating from immense honeycombed bedrock that extends well below the surface. Huge cypress trees, normally associated with swamps of the southeastern United States, border these cold, clear, spring-fed streams, and aquatic life is abundant.

Deep in the heart of the Hill Country is the Llano Uplift, a broad area of ancient igneous and metamorphic rock. The geology is unlike that of the rest of the region: here granite, gneiss, schist, and sandstone dominate the geologic picture, and many plants normally found hundreds of miles to the east do well in the sandy soils.

While the present-day Hill Country has a grace and beauty of its own, it is a far cry from its original state before the first inhabitants. It

Moonrise, Enchanted Rock State Natural Area, Gillespie County

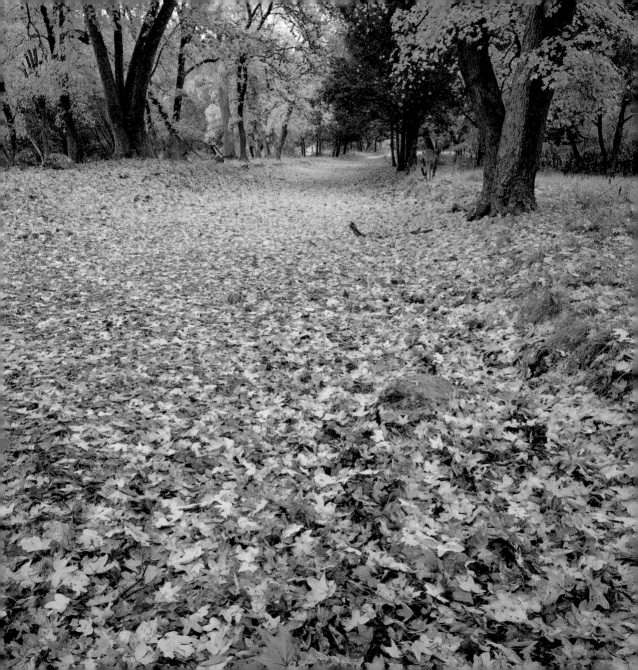

may come as quite a shock to those familiar with the area that the region was once covered by tall grasses and endless vistas of wildflowers. A Texas Ranger who worked in the region from 1875-1881 described it in these words: "In the Springtime, one could travel for hundreds of miles in a bed of flowers. How happy I am now in my old age that I am a native Texan who saw the grand frontier before it was marred by the hand of man."

The Hill Country is truly a place for all seasons. Many people automatically associate it with the spring. To be sure, the profusion of wildflowers here is a spectacle to behold. Good rains in late September and early October are needed to begin the germination process. Bluebonnets are the first to sprout, followed by Indian paintbrush, phlox, gaillardia, coreopsis, and many others.

Summer in the Hill Country is synonymous with "hot," and people here retreat to the cool, clear waters of the Guadalupe, Frio, Nueces, Pedernales and Colorado rivers for relief in the form of swimming, tubing, and canoeing.

Autumn in Central Texas is arguably the best time of year, when Canadian cold fronts are finally strong enough to blow all the way through the state. Oak, elm, sumac, and other trees begin to change color, which often lasts well into December. The relict population of maple trees, hidden within deep canyons of the Frio and Sabinal rivers, often provides a splashy show of color rivaling that of areas much farther north and east.

Winter in the Hill Country offers relatively mild temperatures compared to the rest of the country, and hiking, camping, and backpacking can be much more enjoyable at this time of year than in the warmer seasons. Snow and ice are uncommon, and even when they do occur, they usually melt quickly.

Take time to visit the Hill Country. It is one of Texas' most scenic and beautiful areas, and there are treasures waiting to be found by those who take the time to explore its natural wonders.

—Richard Reynolds
Austin, Texas

Autumn leaves, Lost Maples State Natural Area, Bandera County

"It was once barren land. The angular hills
were covered with scrub cedar and a few live oaks....
And each spring the Pedernales River would flood the valley....
Today that country is abundant with fruit, cattle, goats, and sheep.
There are pleasant homes and lakes, and the floods are gone...."

— President Lyndon Baines Johnson, State of the Union Message, 1965

Waterfalls, Pedernales River, Pedernales Falls State Park, Blanco County

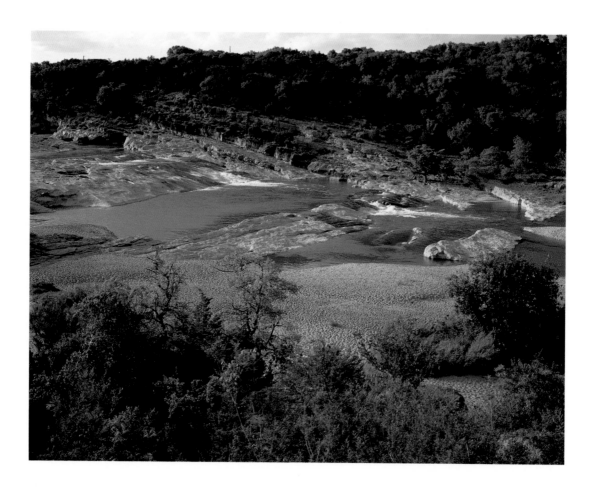

"The sky is the daily bread of the eyes."

— Ralph Waldo Emerson, *Journal*

Clouds building at sunset, Bandera County

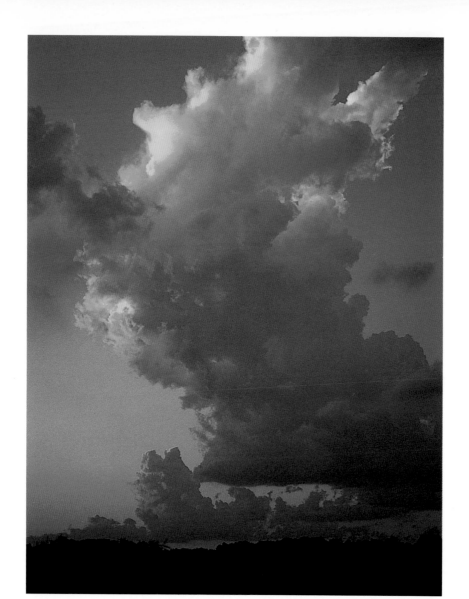

"Spring has returned.
The earth is like
a child that knows poems."

— Rainer Marie Rilke, *Die Sonette an Orpheus*

Spiderwort and ferns, Enchanted Rock State Natural Area,
Gillespie County

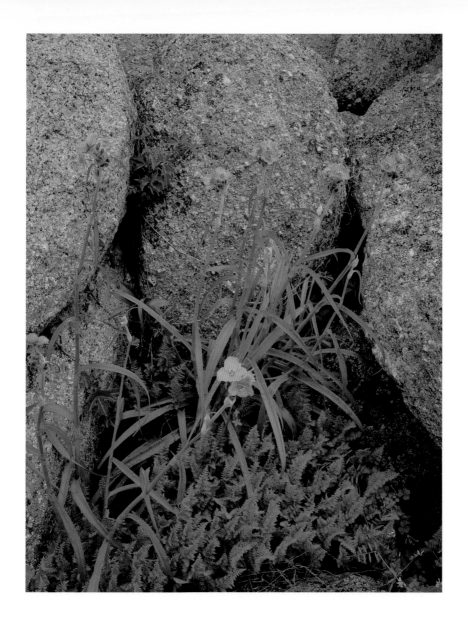

"A river seems a magic thing. A magic, moving, living part of the very earth itself...."

— Laura Gilpin, *The Rio Grande*

Cascade on the Guadalupe River, Kerr County

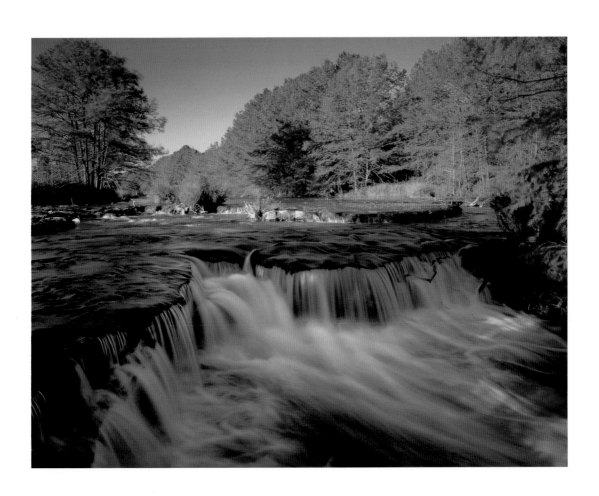

"To every thing there is a season,

and a time to every purpose under heaven…"

— *Ecclesiastes 3:1*

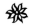

Agarita and autumn maple leaves, Lost Maples State Natural Area,
Bandera County

Overleaf: Bluebonnets beside railroad tracks, Llano County

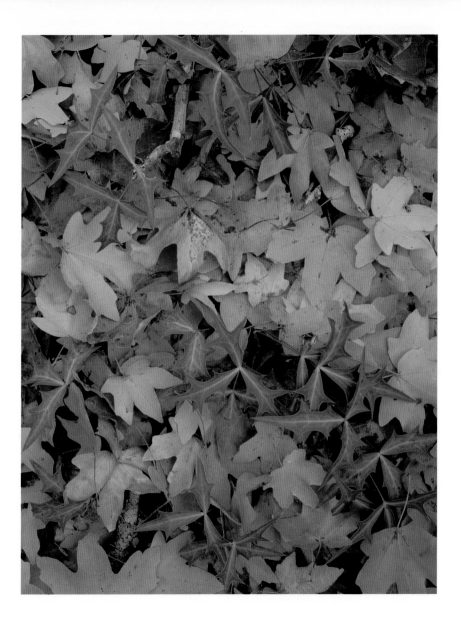

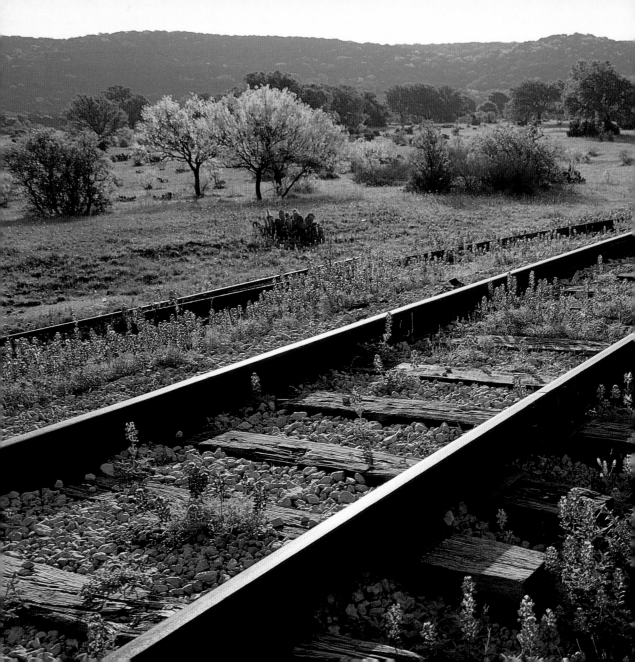

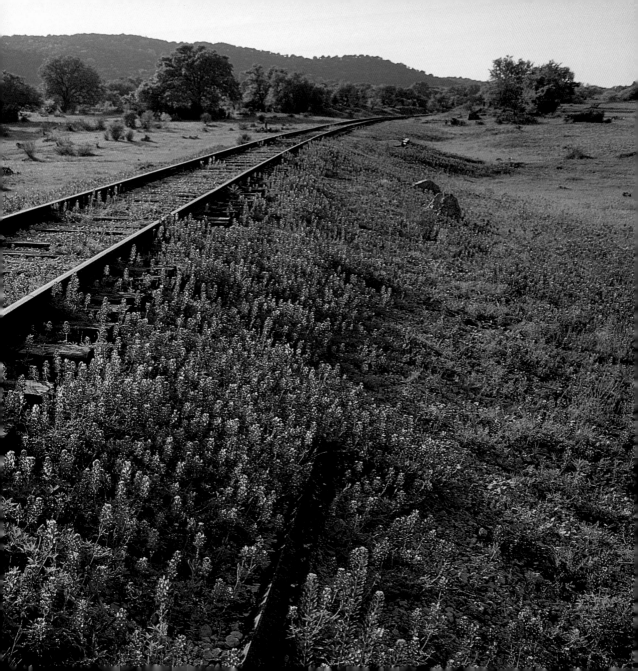

"The boughs of no two trees ever have the same arrangement.
Nature always produces *individuals*; she never produces *classes*."

— Lydia Maria Child, *Letters from New York*

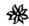

Sunset silhouette, Real County

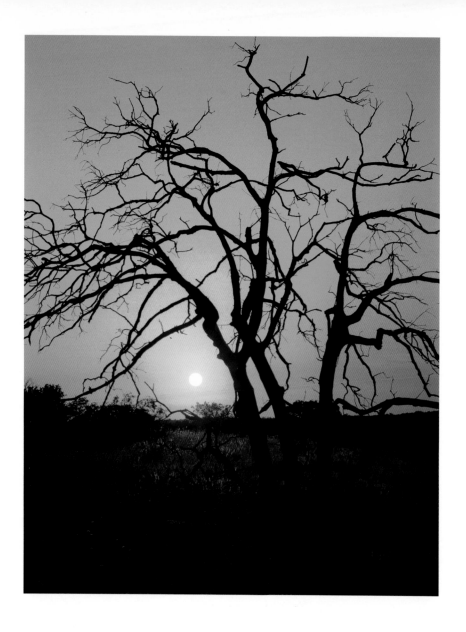

"Mr. Giles's ranch...looks in the summer, when the imported Scotch cattle are grazing over it, like a bit out of the Lake country. Walnut, cherry, ash, and oak grow on this ranch, and...the flowers are boundless in profusion and variety."

— Richard Harding Davis, *The West From a Car-Window*

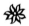

Horsemint, phlox, coreopsis, and gaillardia, McCulloch County

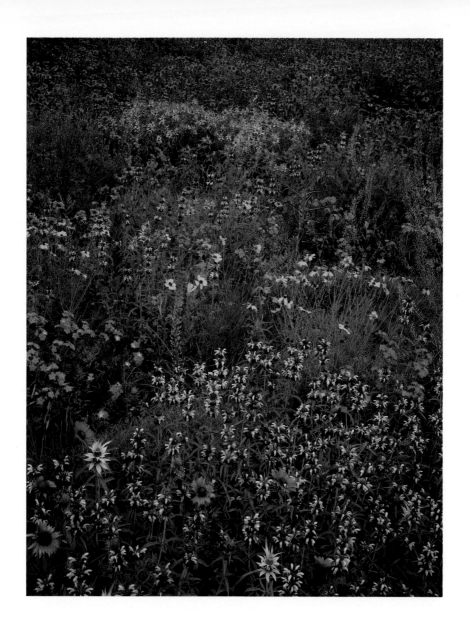

"...let them [people] dream life just as the lake dreams the sky."

— Miguel de Unamuno, *San Miguel Bueno*

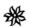

Sunset reflections in Lake Buchanan, Burnet County

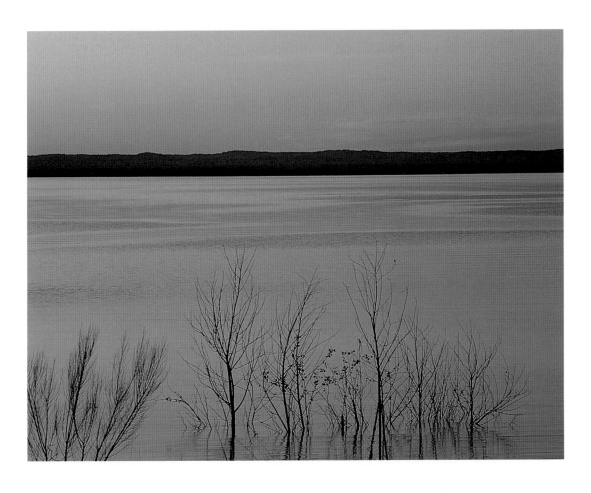

"Everything is only for a day,
both that which remembers
and that which is remembered."

— Marcus Aurelius, *Meditations*

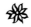

Fall foliage, Lost Maples State Natural Area, Bandera County

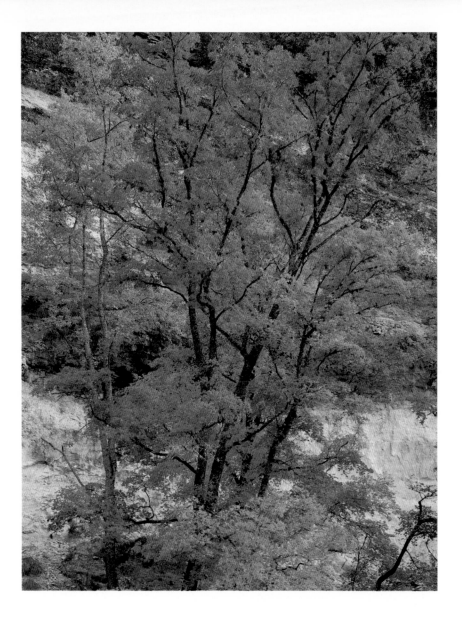

"It is a country where...everything that grows has a thorn."

— Richard Harding Davis, *The West From a Car-Window*

Prickly pear blossoms, Enchanted Rock State Natural Area,
Gillespie County

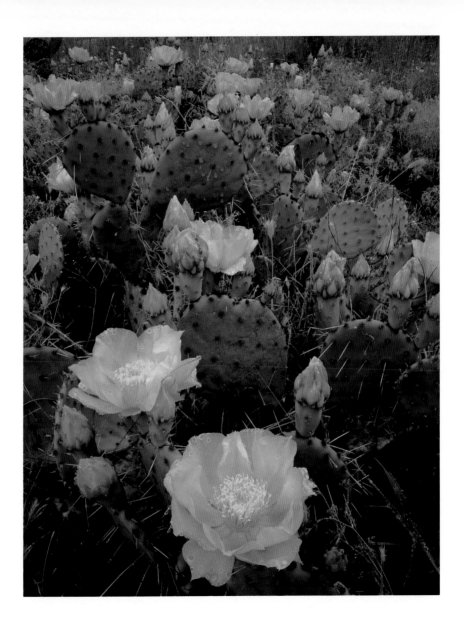

"Above the city of Austin, between the Brazos and the Colorado....Lime stone of the finest quality abounds, much of which by the fineness of its grain, seems capable of being elegantly polished."

— Anonymous, *Texas in 1840*

Sunset above Enchanted Rock State Natural Area, Gillespie County

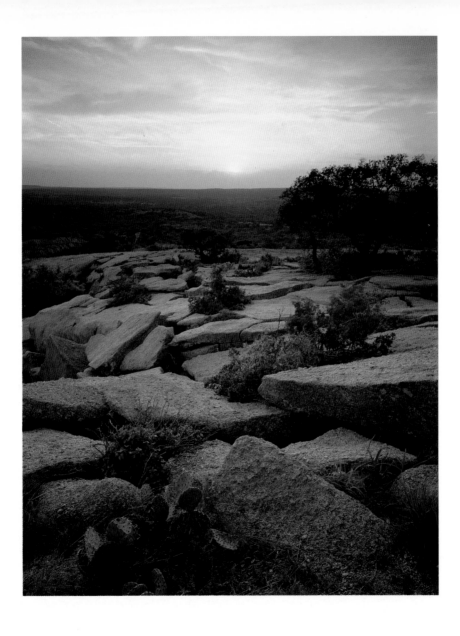

"There is always a *but* in this imperfect world."

— Anne Brontë, *The Tenant of Wildfell Hall*

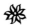

Albino bluebonnet, Burnet County

Overleaf: Indian paintbrush and bluebonnets, Burnet County

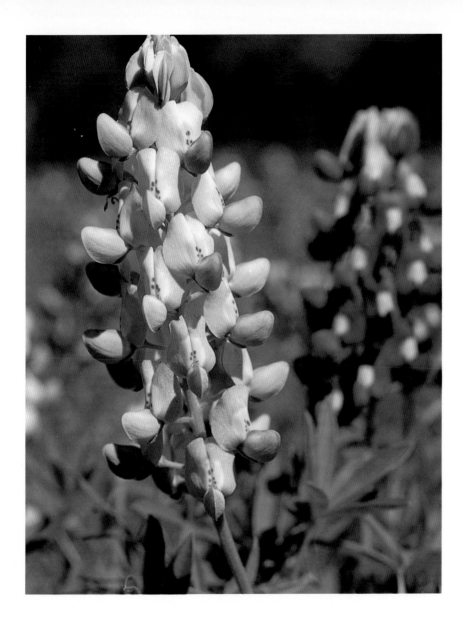

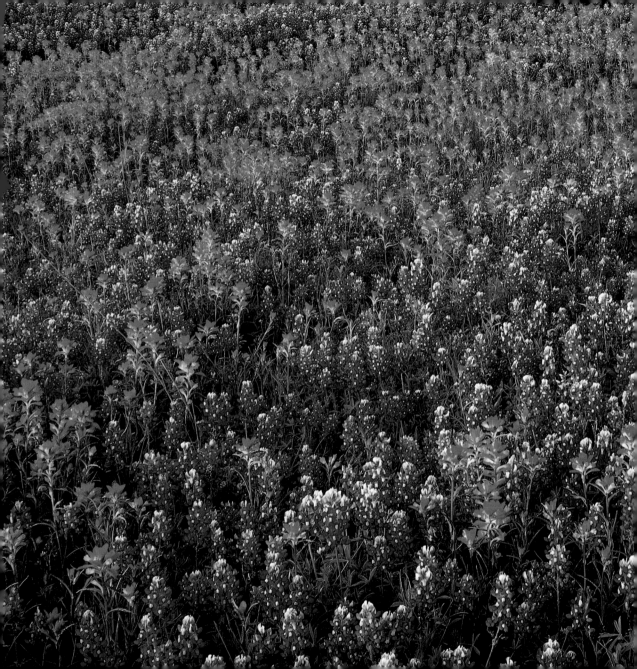

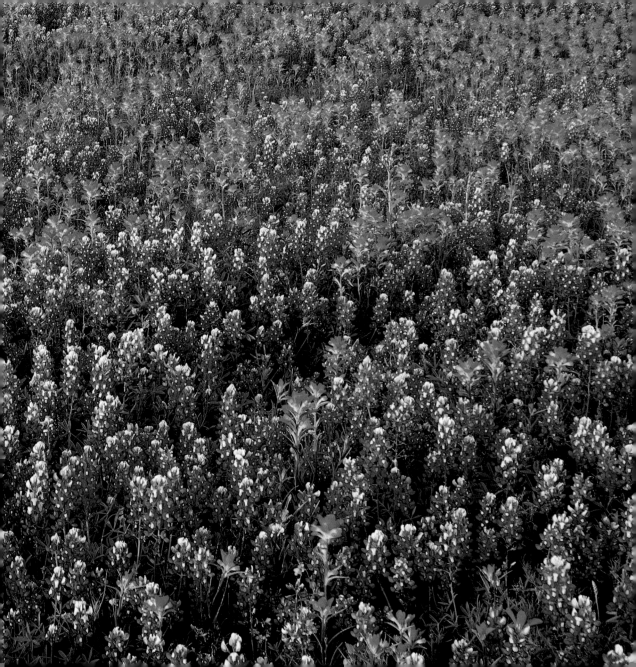

"The prairies were laughing with flowers in ravishing luxuriance, whole acres of green being often entirely lost under their decoration of blue and purple."

— Frederick Law Olmsted, *A Journey Through Texas*

Nodding thistle, Kerr County

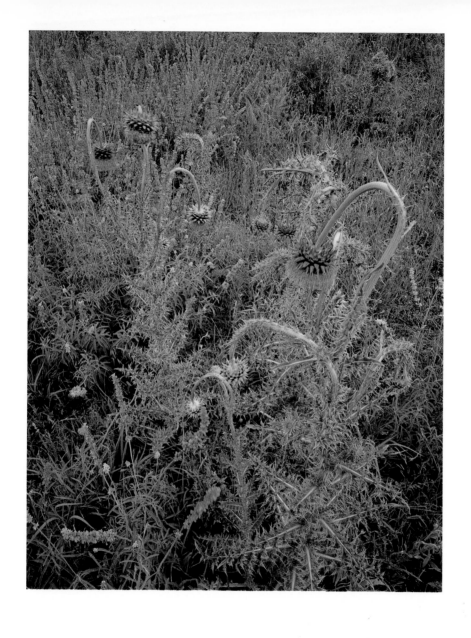

"There was formerly an old Spanish road run from Gonzales to San Saba....That road runs over a beautifully undulating country, with an abundant supply of water...."

— Anonymous, *Texas in 1840*

Guadalupe River, Comal County

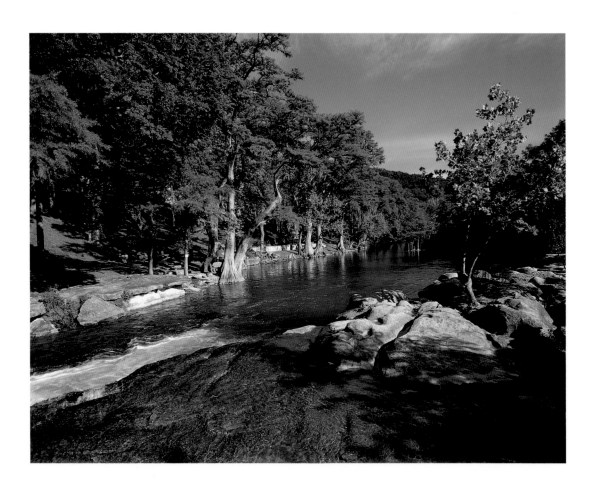

"Let us cross over the river, and rest under the shade of the trees."

— T. J. (Stonewall) Jackson

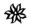

Maple tree along the Sabinal River, Lost Maples State Natural Area

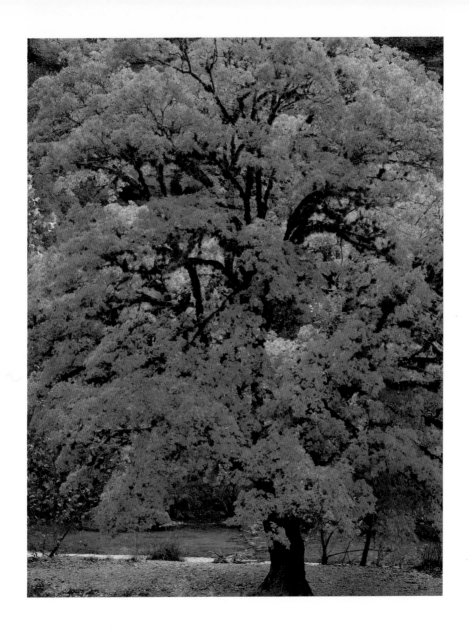

"Fair flower, that dost so comely grow,

Hid in this silent, dull retreat,

Untouched thy honied blossoms blow,

Unseen thy little branches greet:

No roving foot shall crush thee here,

No busy hand provoke a tear..."

— Philip Freneau, *The Wild Honey Suckle*

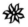

Bluebonnets amid lichen-covered boulders,
Inks Lake State Park, Burnet County

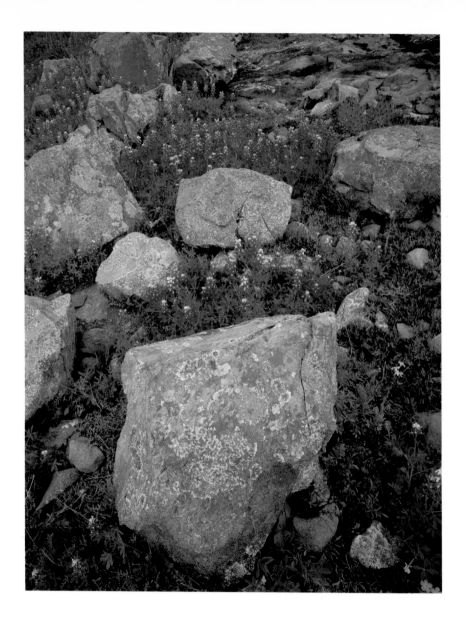

"Delicious autumn! My very soul is wedded to it, and if I were a bird I would fly about the earth seeking the successive autumns."

— George Eliot, *George Eliot's Life as Related in Her Letters and Journals*

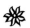

Maple leaves in grass, Lost Maples State Natural Area, Bandera County

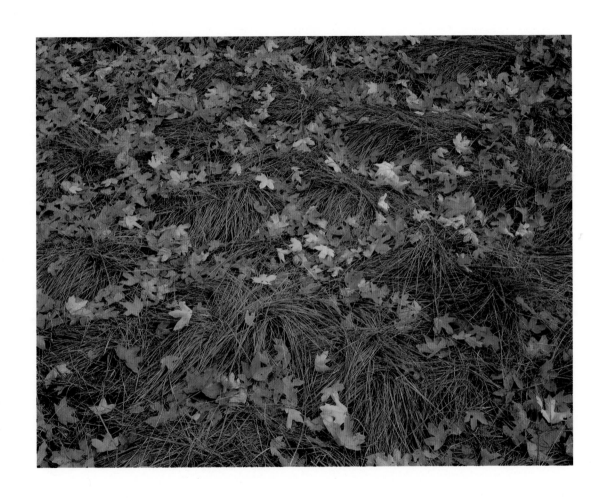

"As the days take on a mellower light...
Then for the teeming quietest, happiest days of all!
The brooding and blissful halcyon days!

— Walt Whitman, *Halcyon Days*

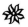

Autumn light reflected in Onion Creek,
McKinney Falls State Park, Travis County

Overleaf: Summer day, Real County

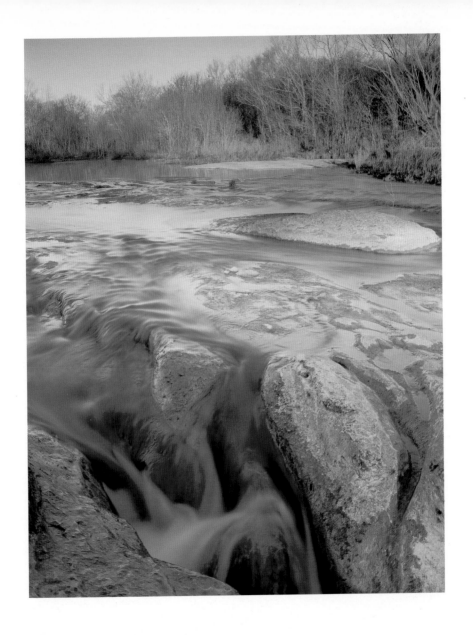

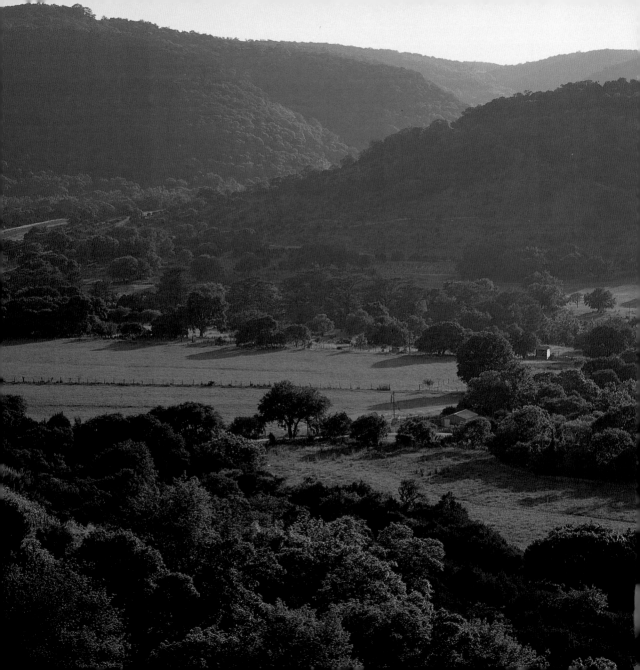

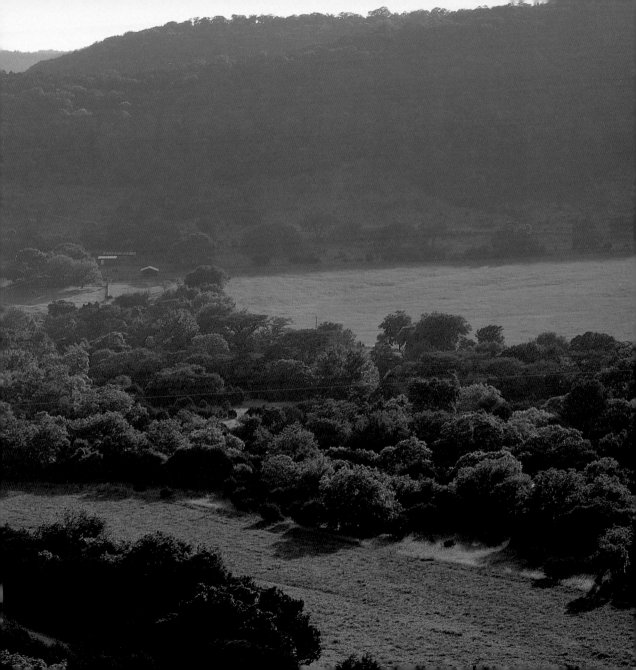

"The mist, like love, plays upon the heart of the hills
and brings out surprises of beauty."

— Rabindranath Tagore, *Stray Birds*

Bluebell gentian flowers, Blanco County

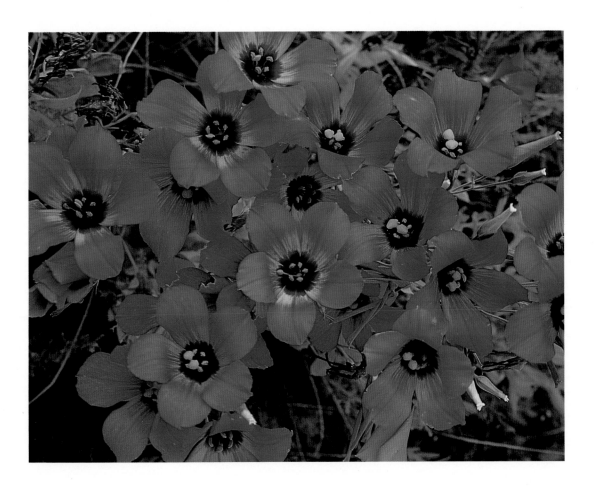

"To him who in the love of Nature holds
Communion with her visible forms, she speaks
A various language...
She has a voice of gladness, and a smile
And eloquence of beauty..."

— William Cullen Bryant, *Thanatopsis*

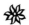

Granite rock forms, Enchanted Rock State Natural Area,
Gillespie County

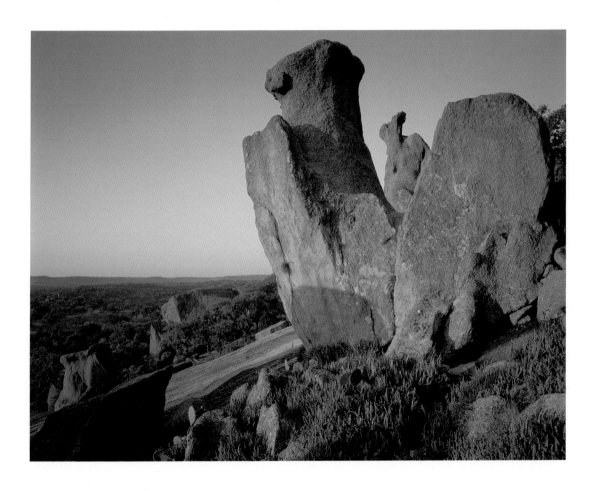

"To create a little flower is the labour of ages."

— William Blake, *Proverbs of Hell*

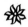

Verbena and greenthread, Edwards County

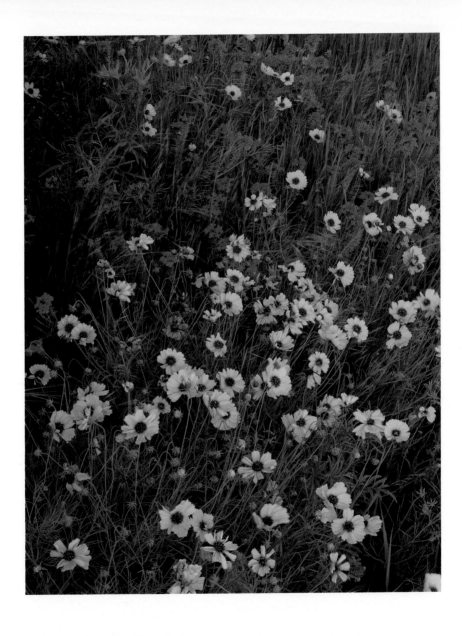

"I was…informed that the country between the Colorado and Brazos Rivers, in a N.E. direction from about Austin, is most eligible for settlers, indeed; it is called the 'Land of beauty.'"

— William Bollaert, *William Bollaert's Texas*

Hill Country vista, Bandera County

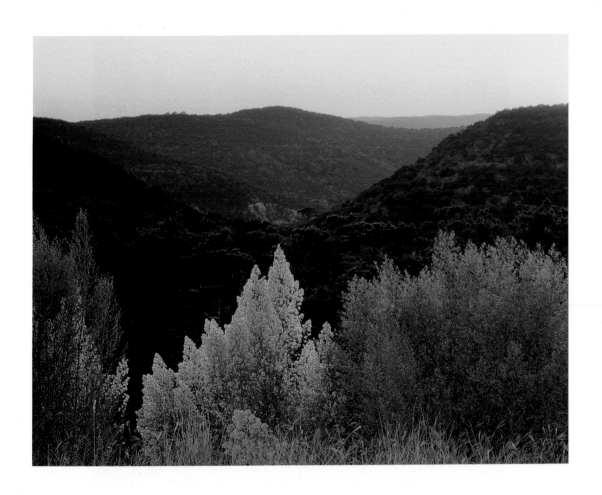

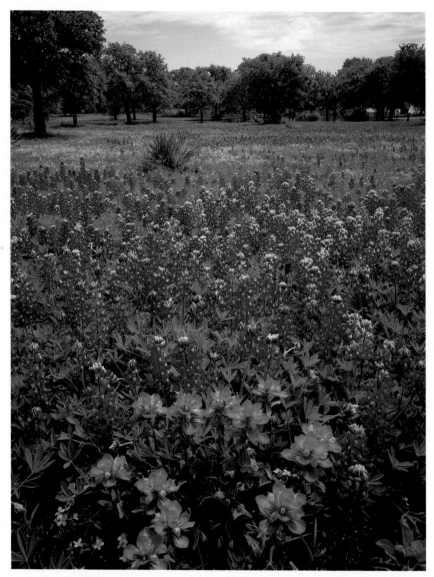

Bluebonnets, popweed, and Indian paintbrush, Llano County